EggStatic Art
Coloring Book for the Mind

By
Aphrodite Theodosakos Antoniou

WWW.FACEBOOK.COM/APHRODITEARTSCAPE2016

First Printing

All images in this book are illustrated by
Aphrodite Theodosakos Antoniou
© Aphrodite Theodosakos Antoniou, 2016

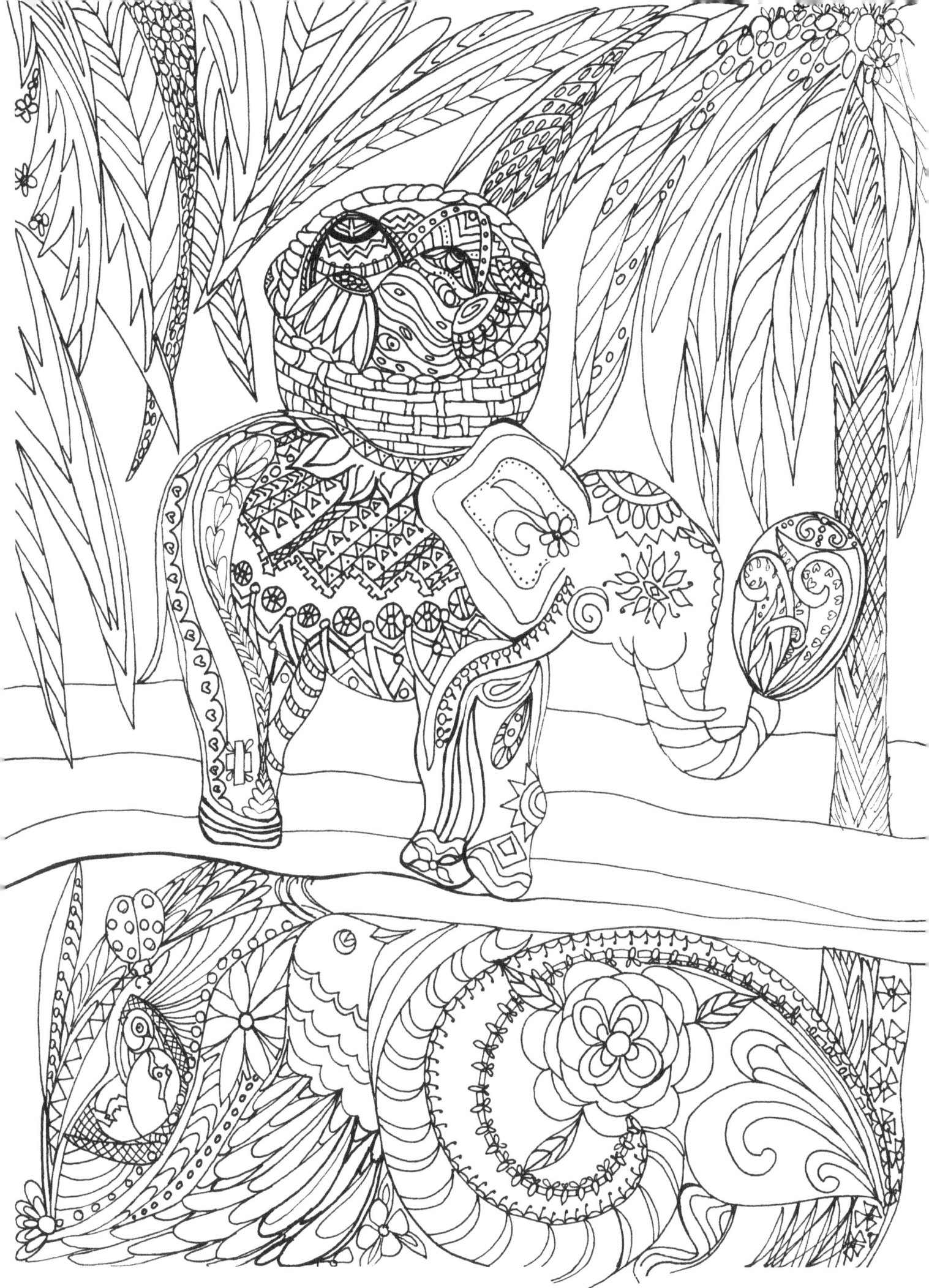

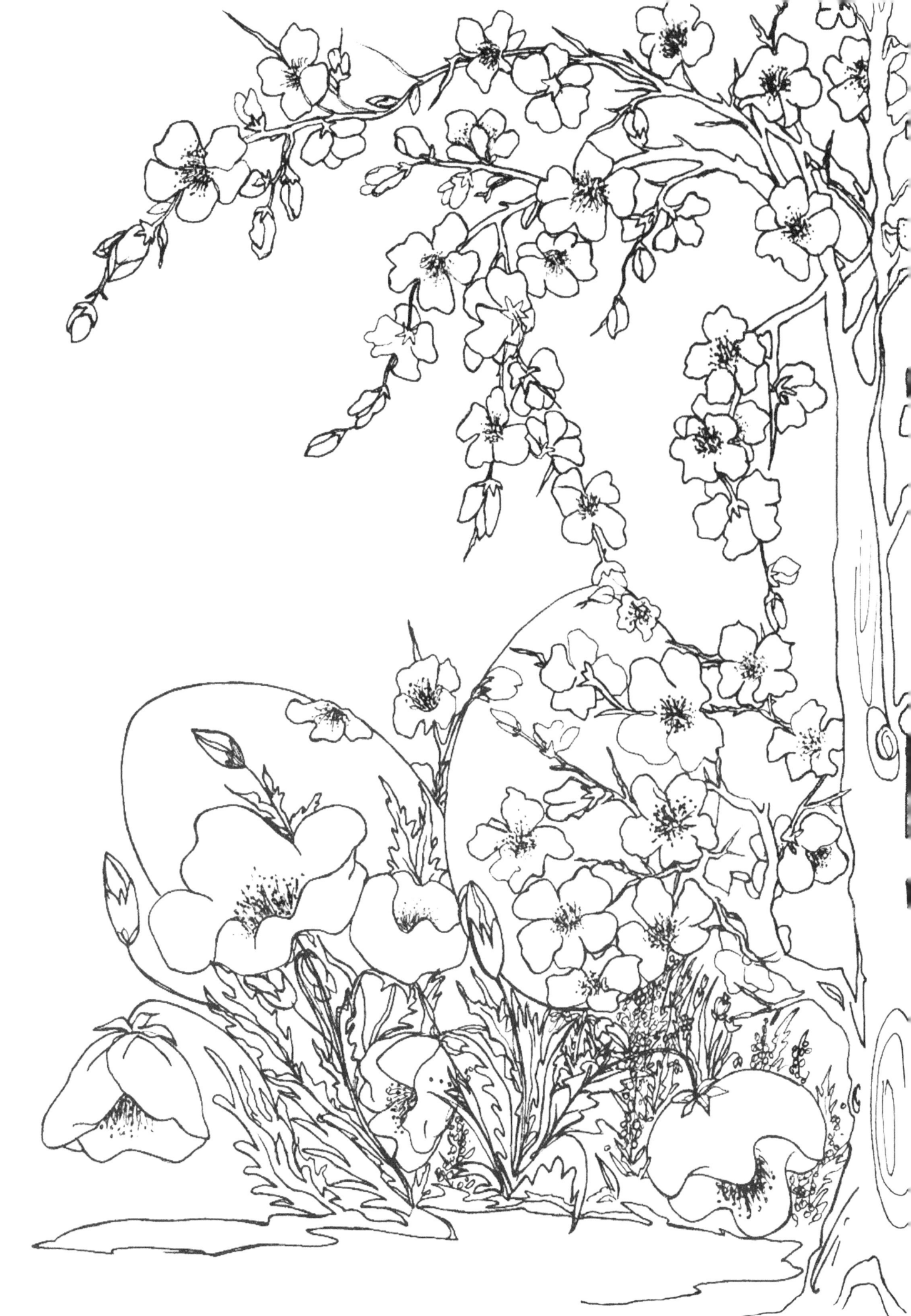

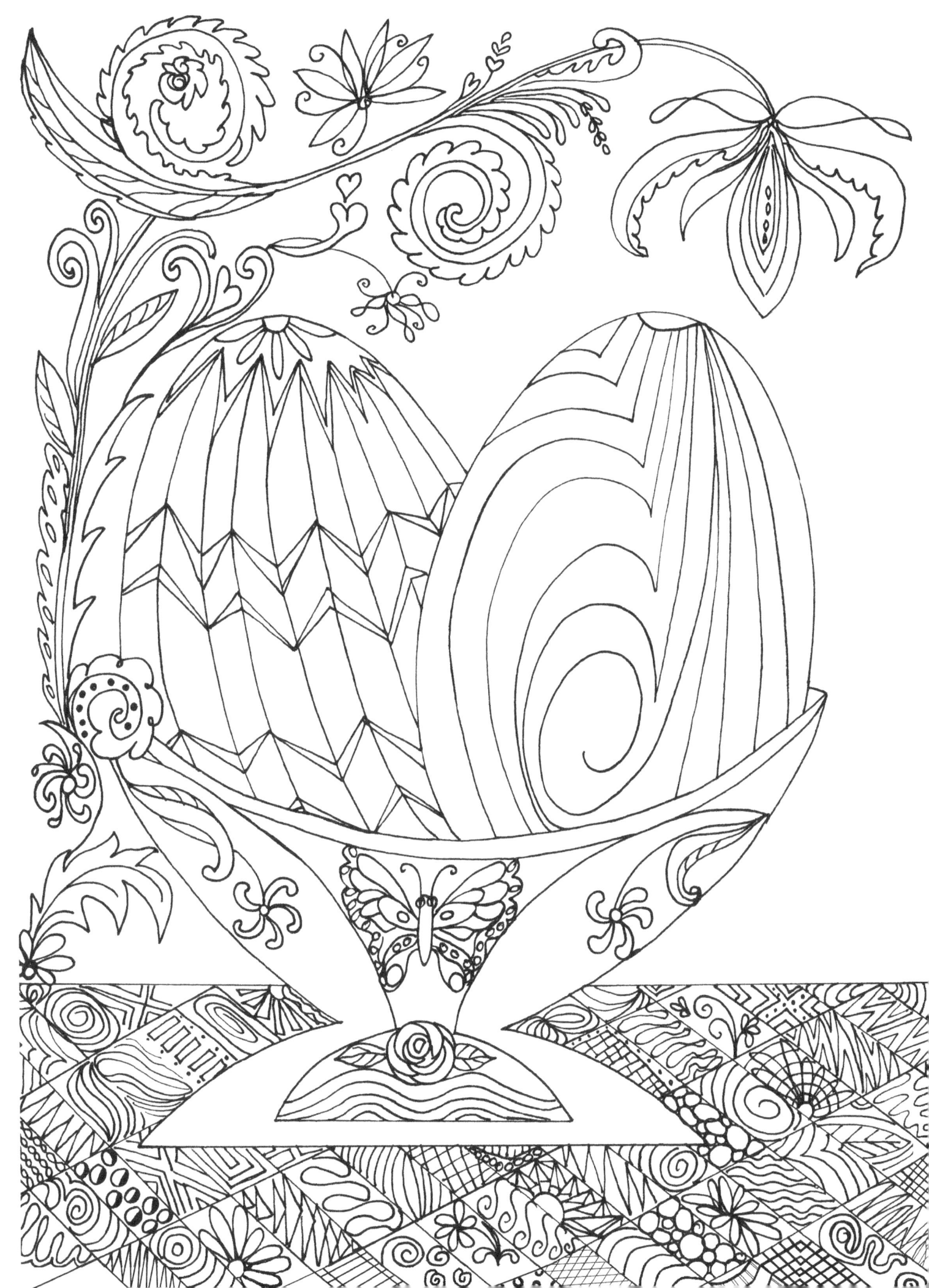

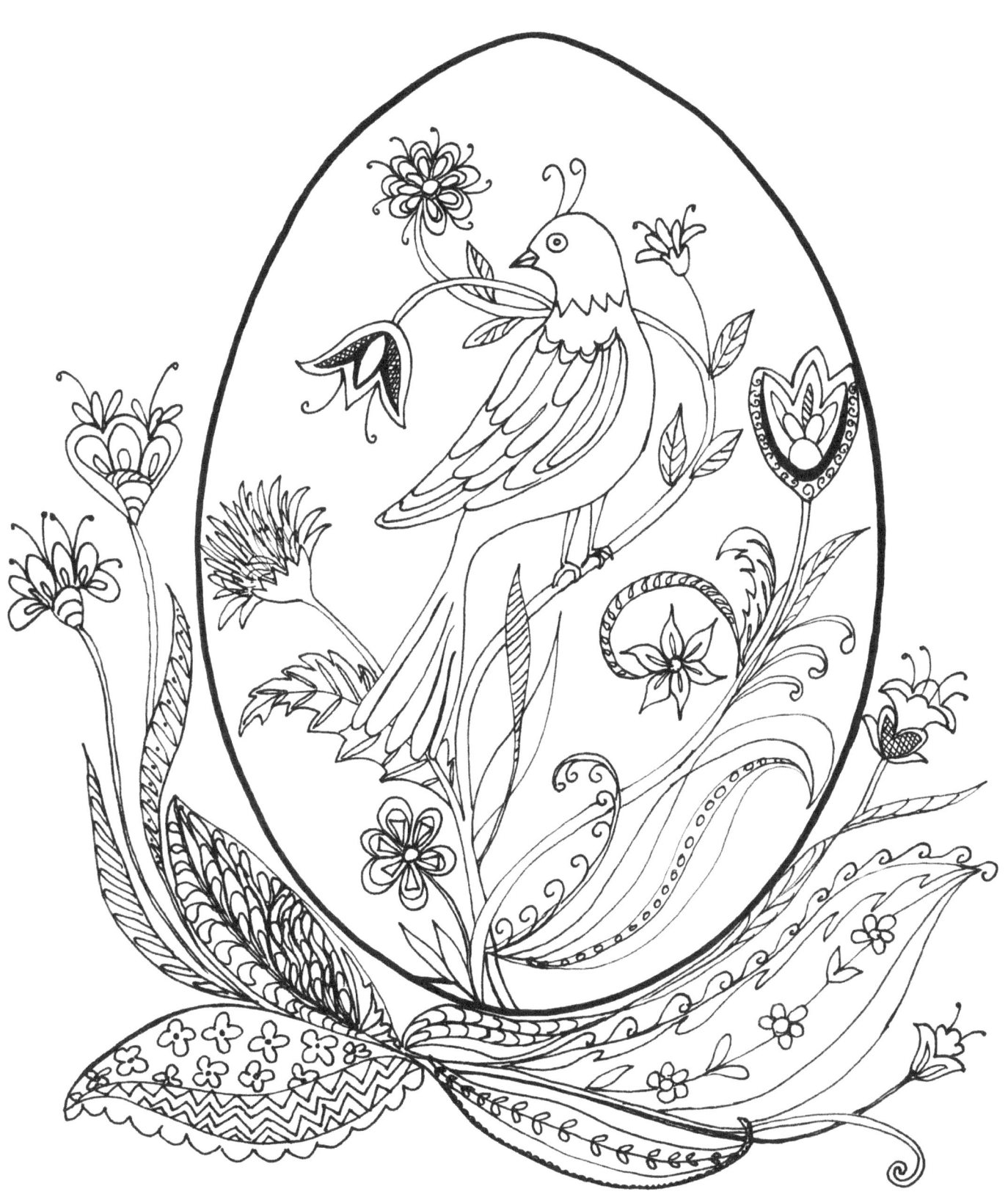

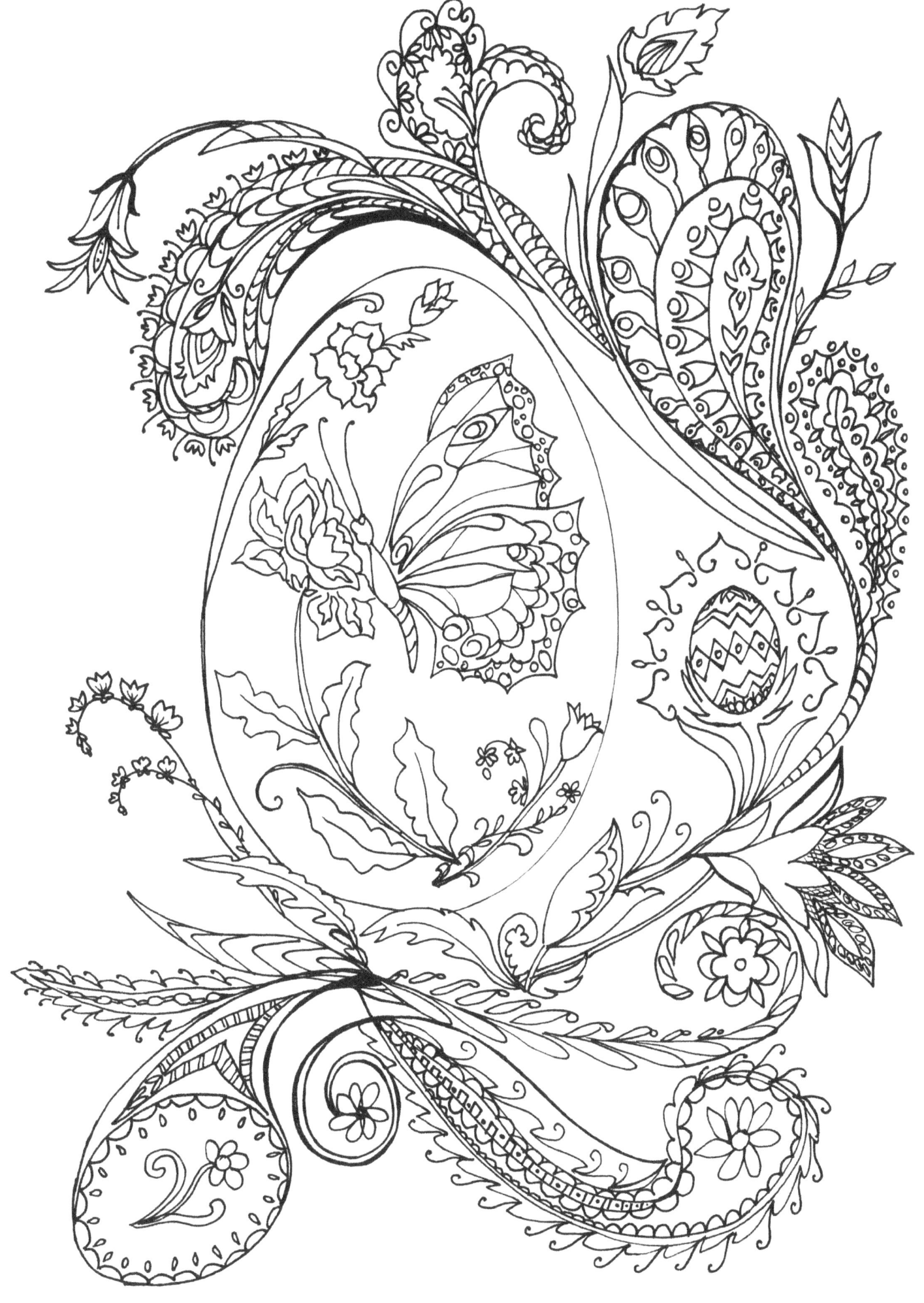

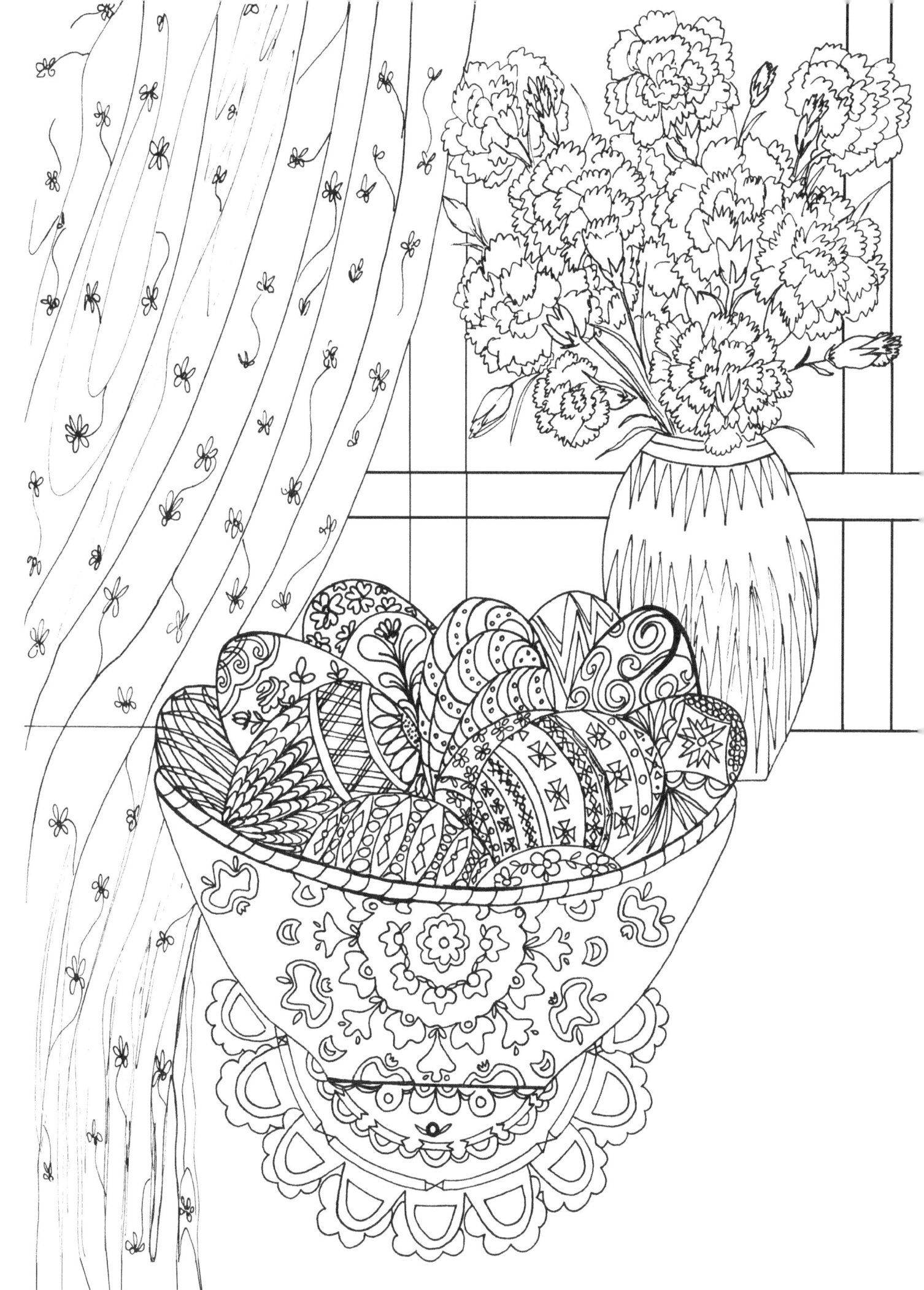

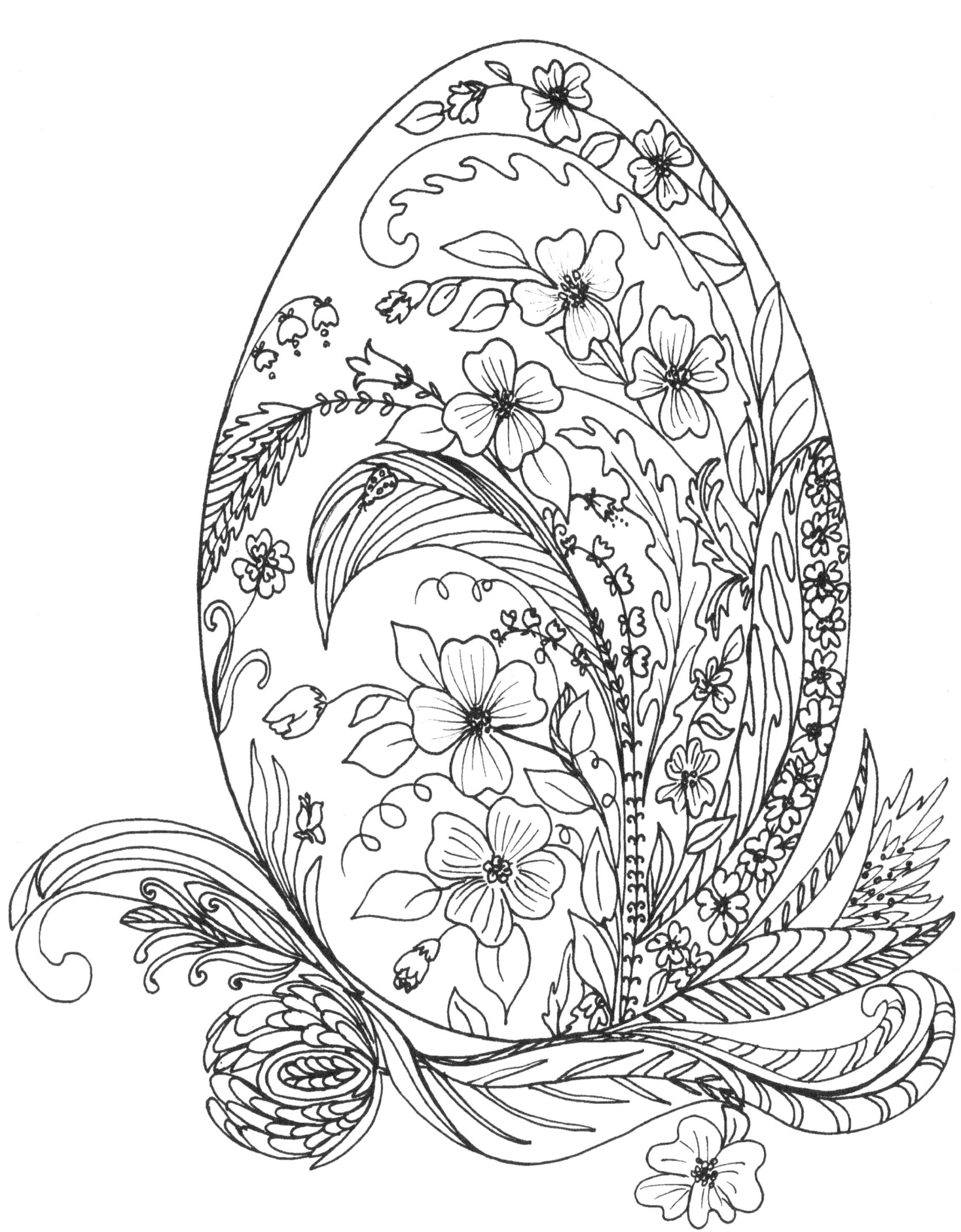

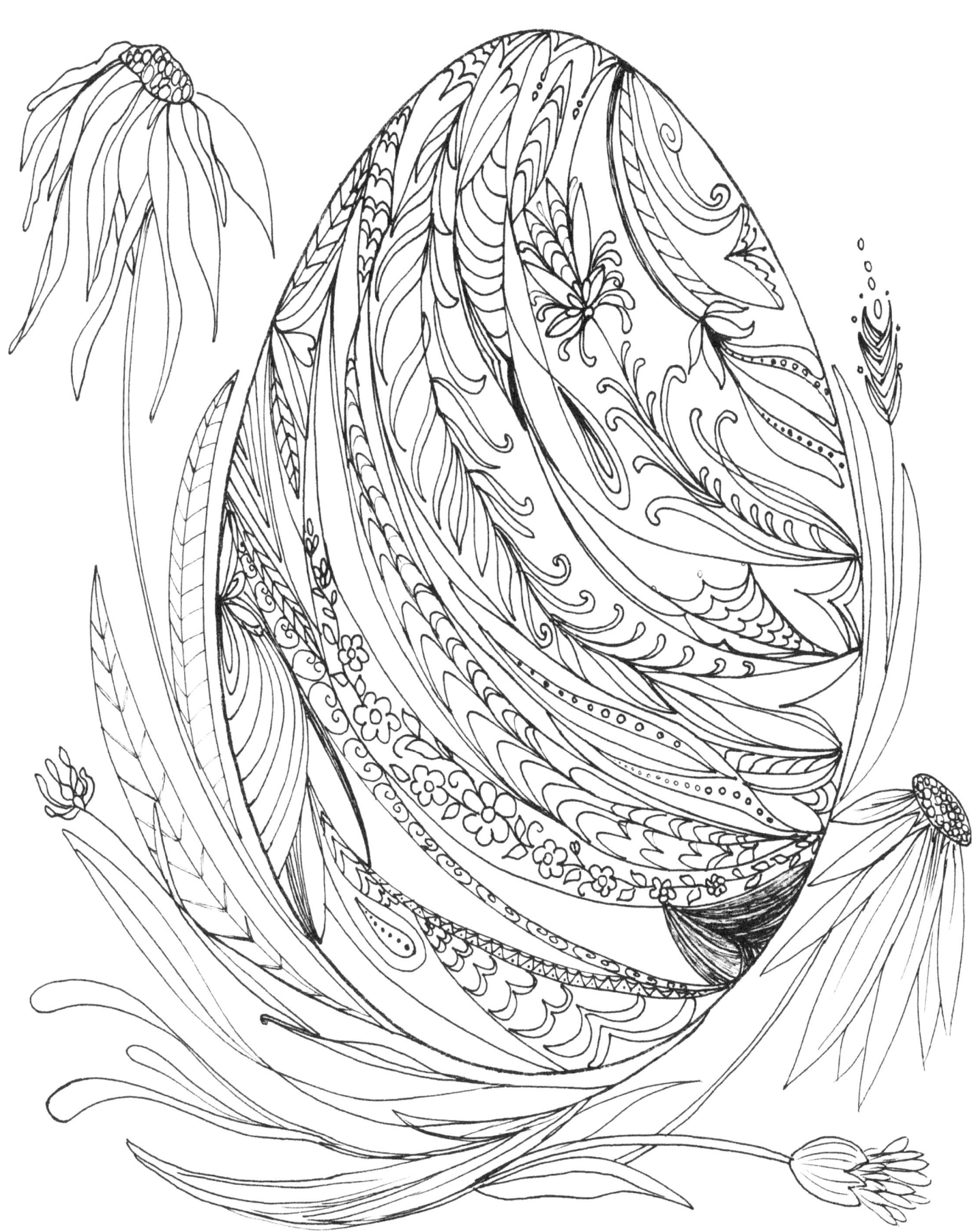

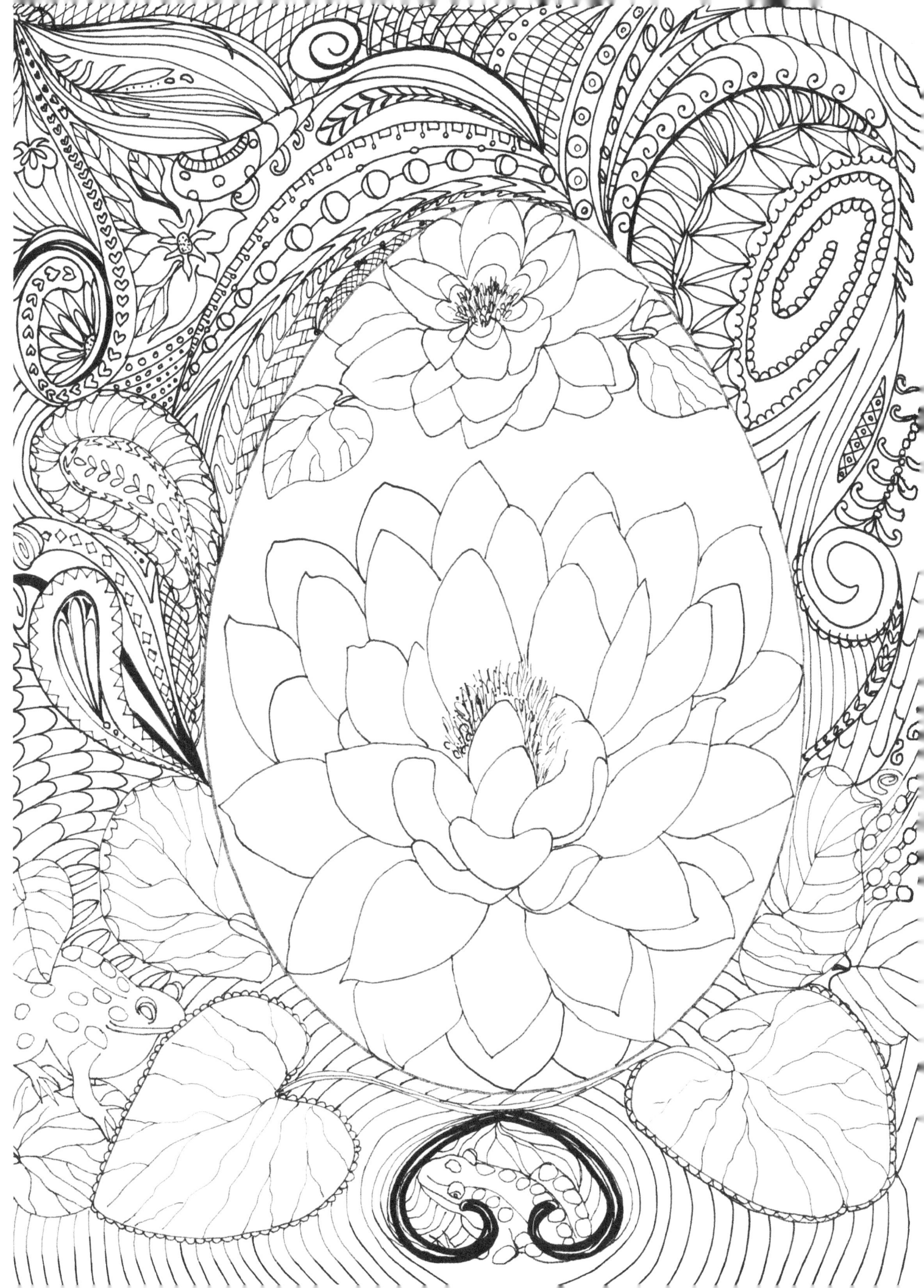

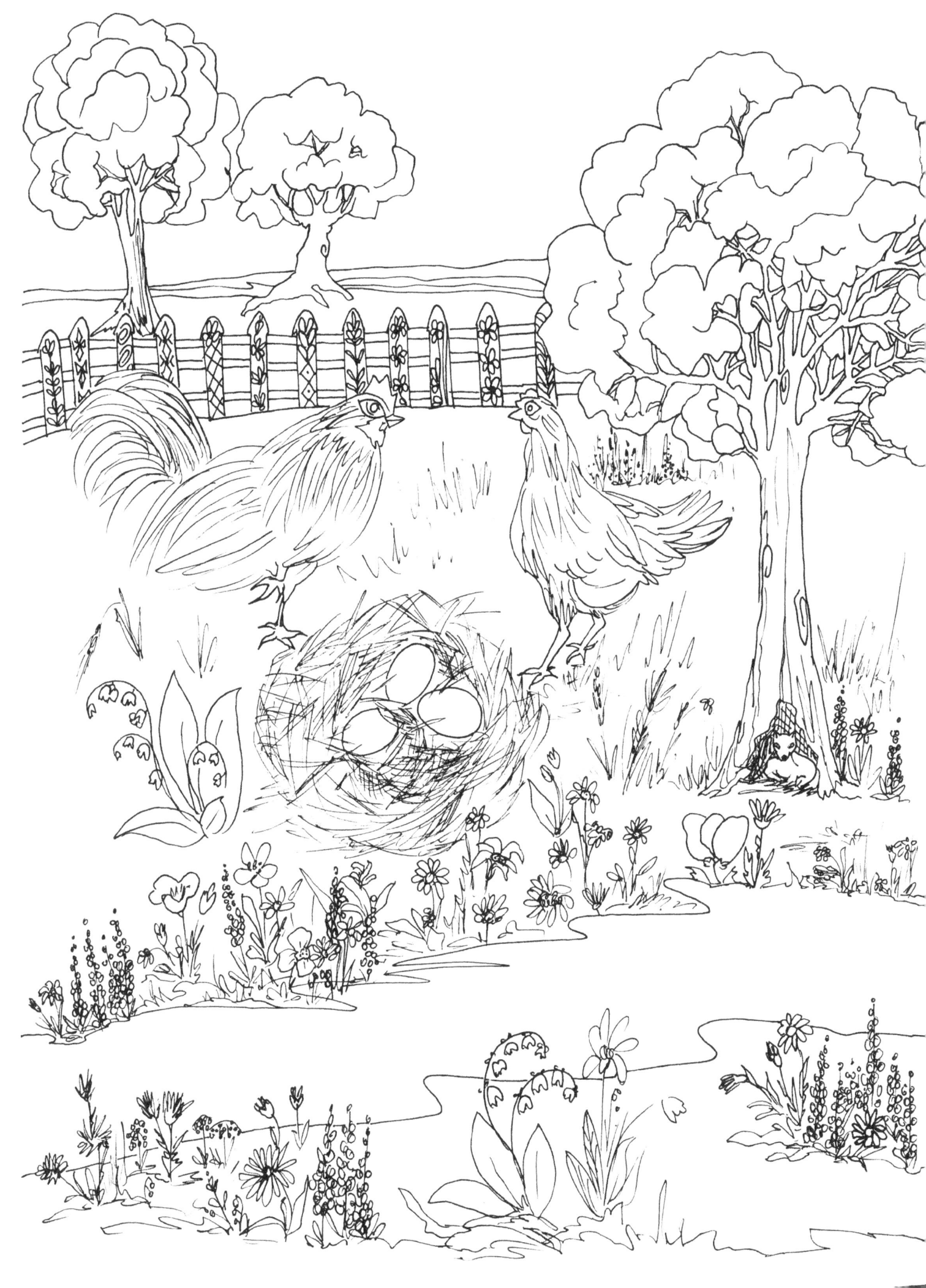

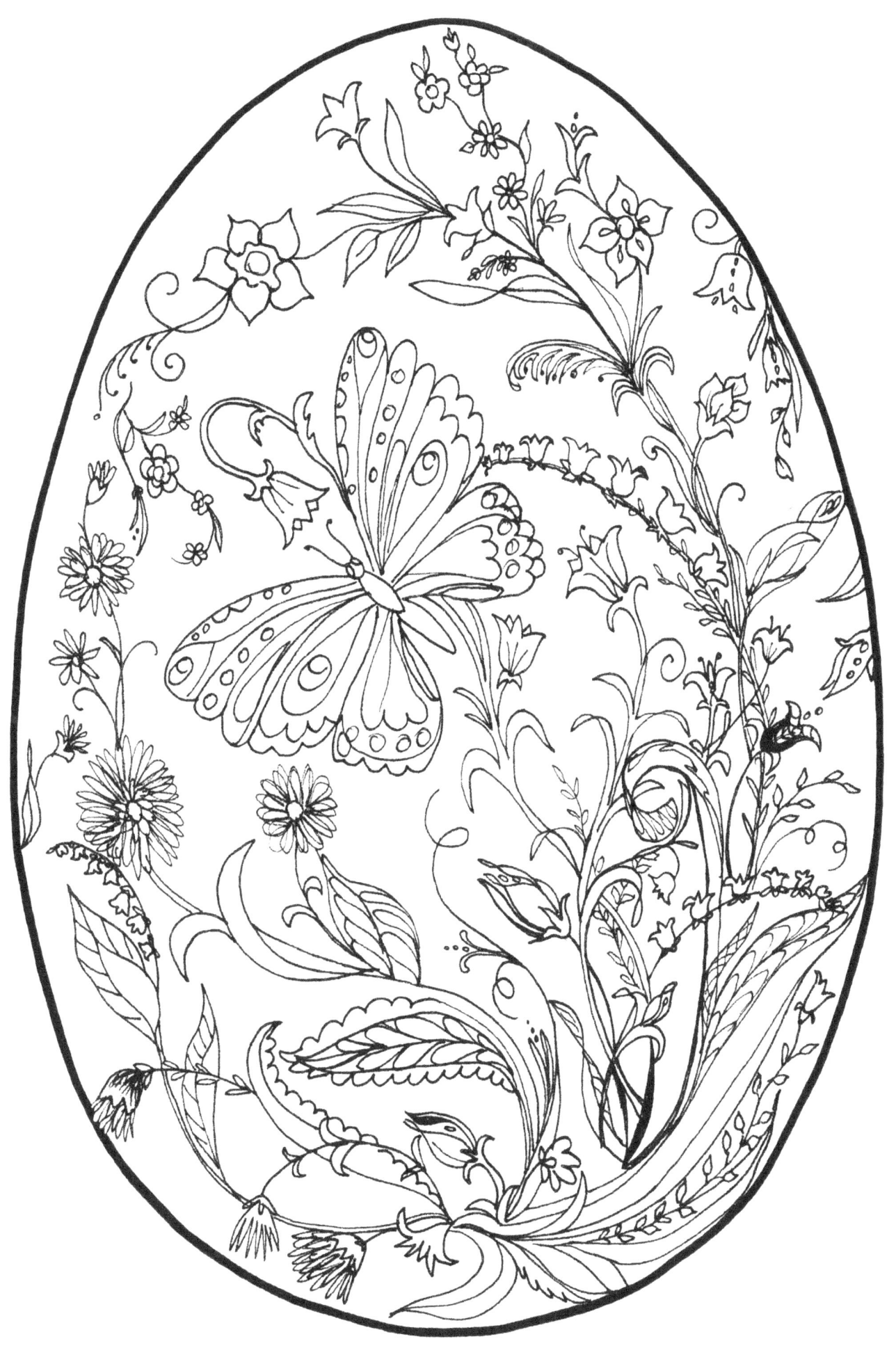

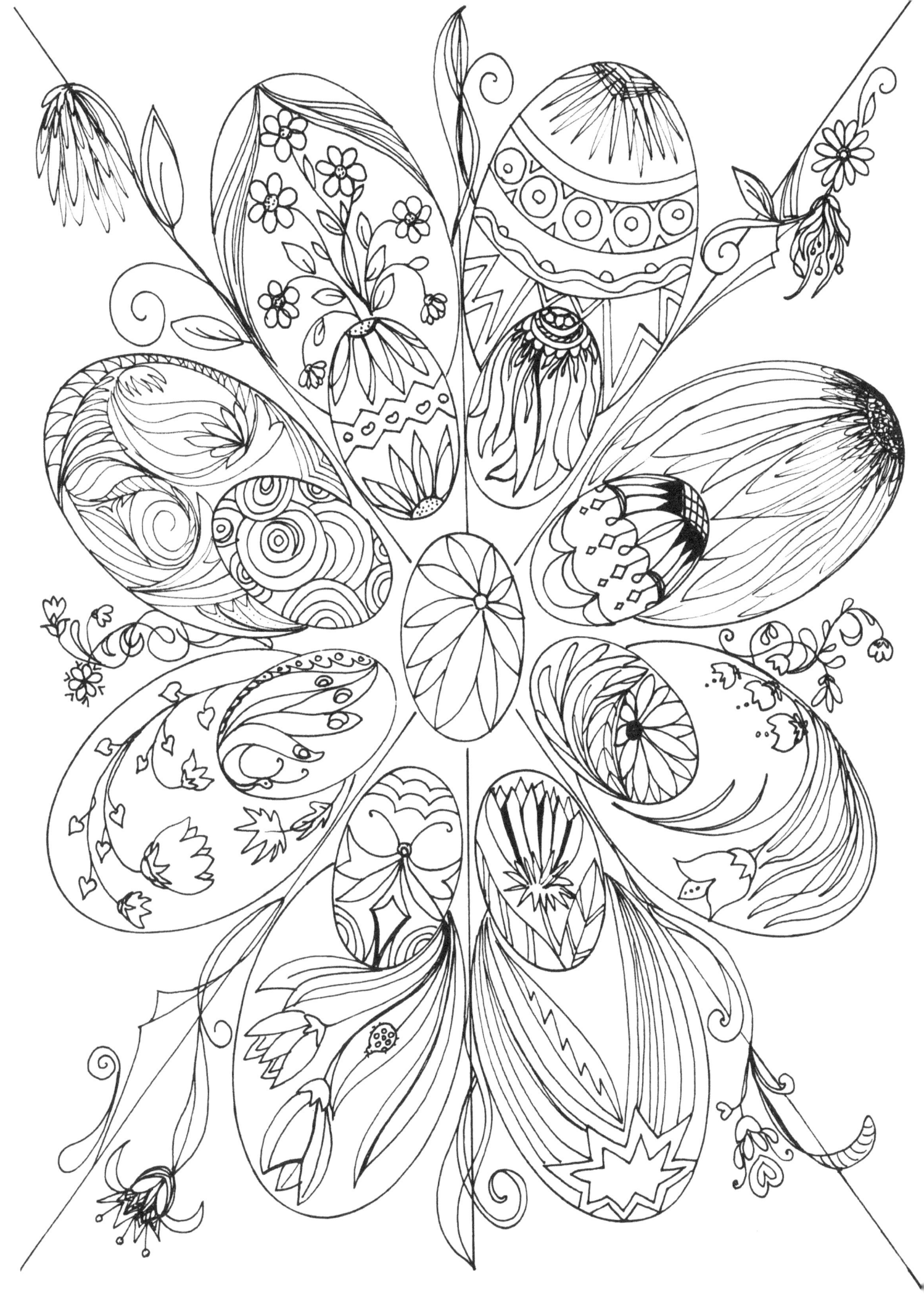

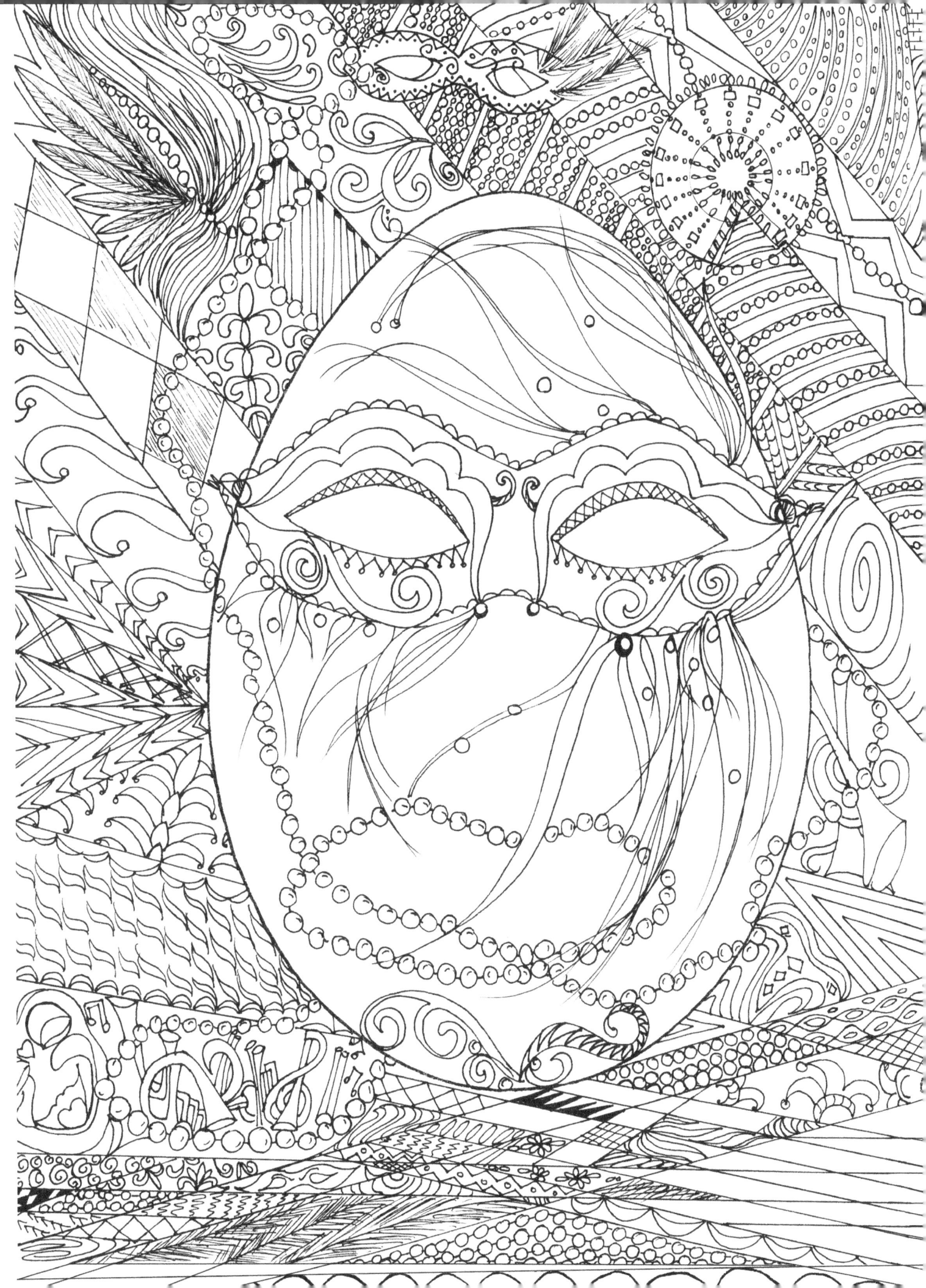

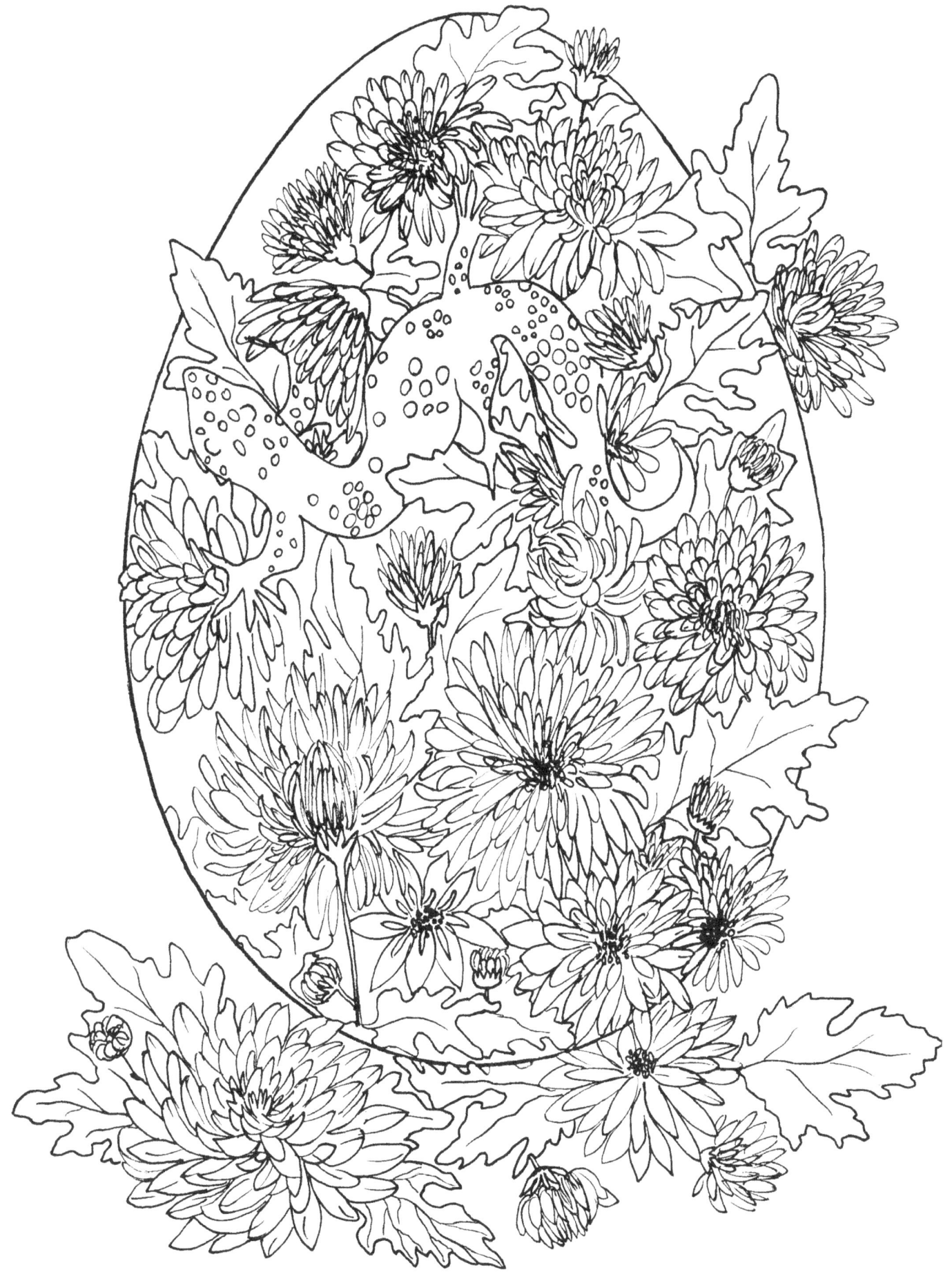

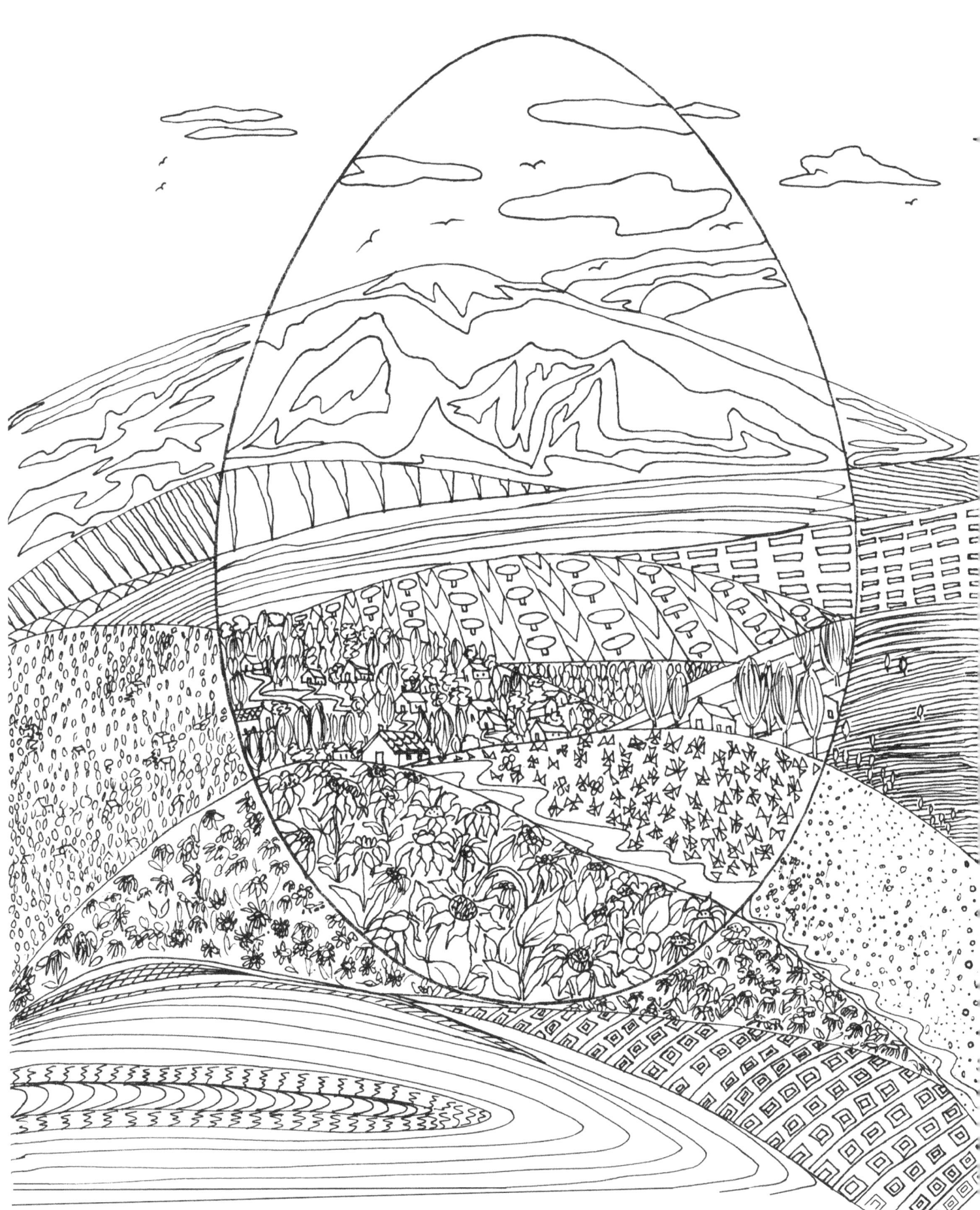

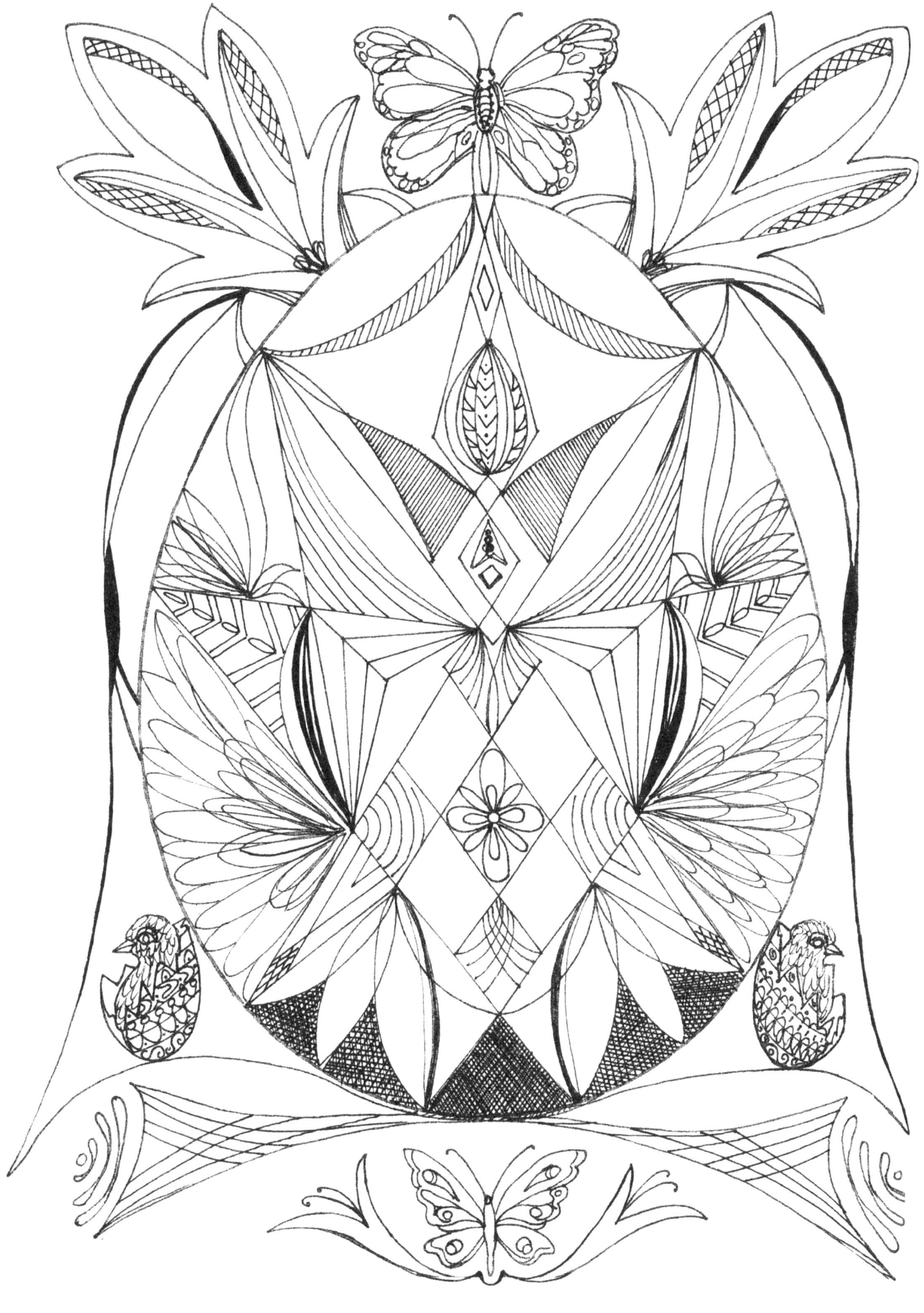

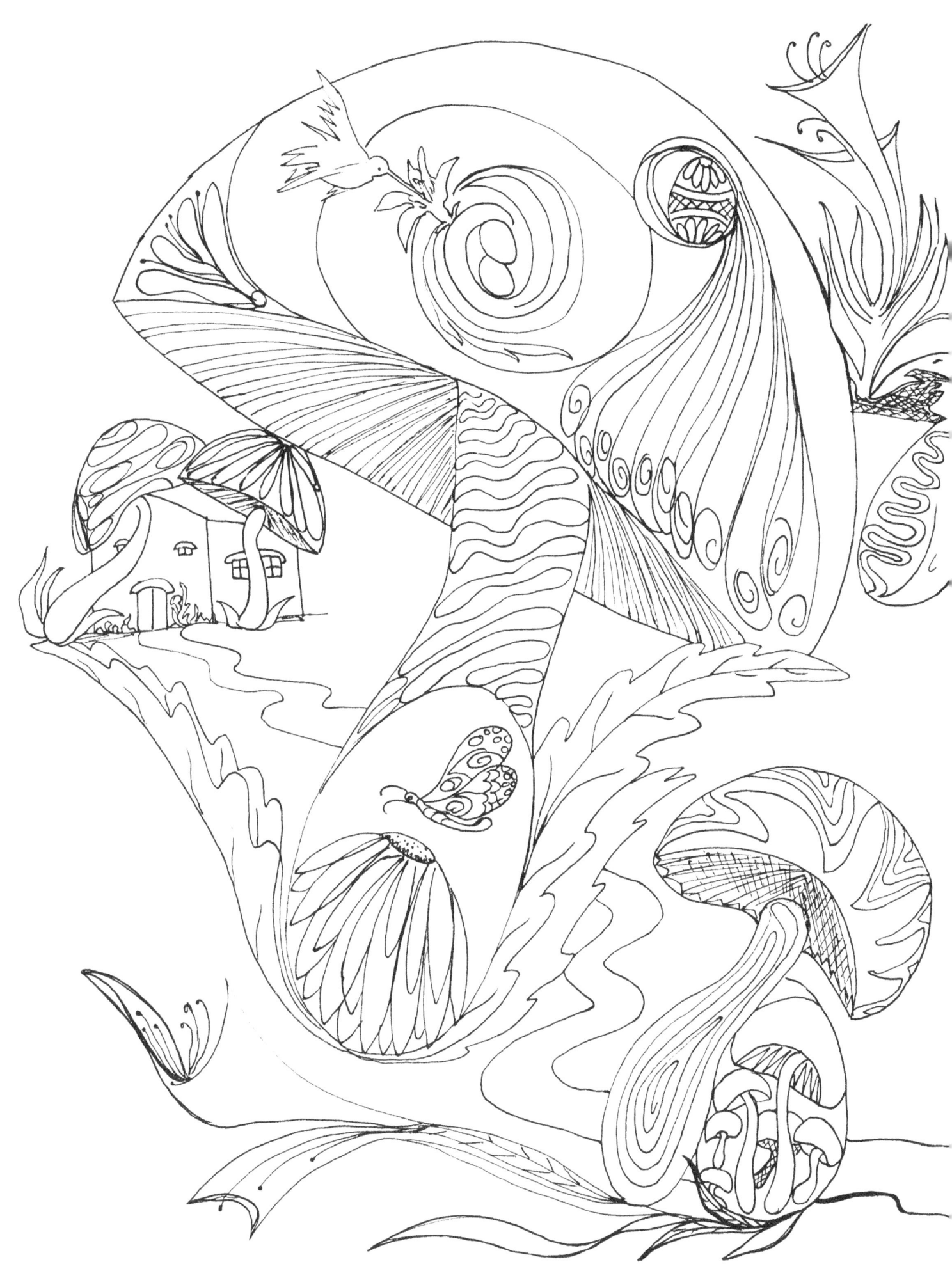

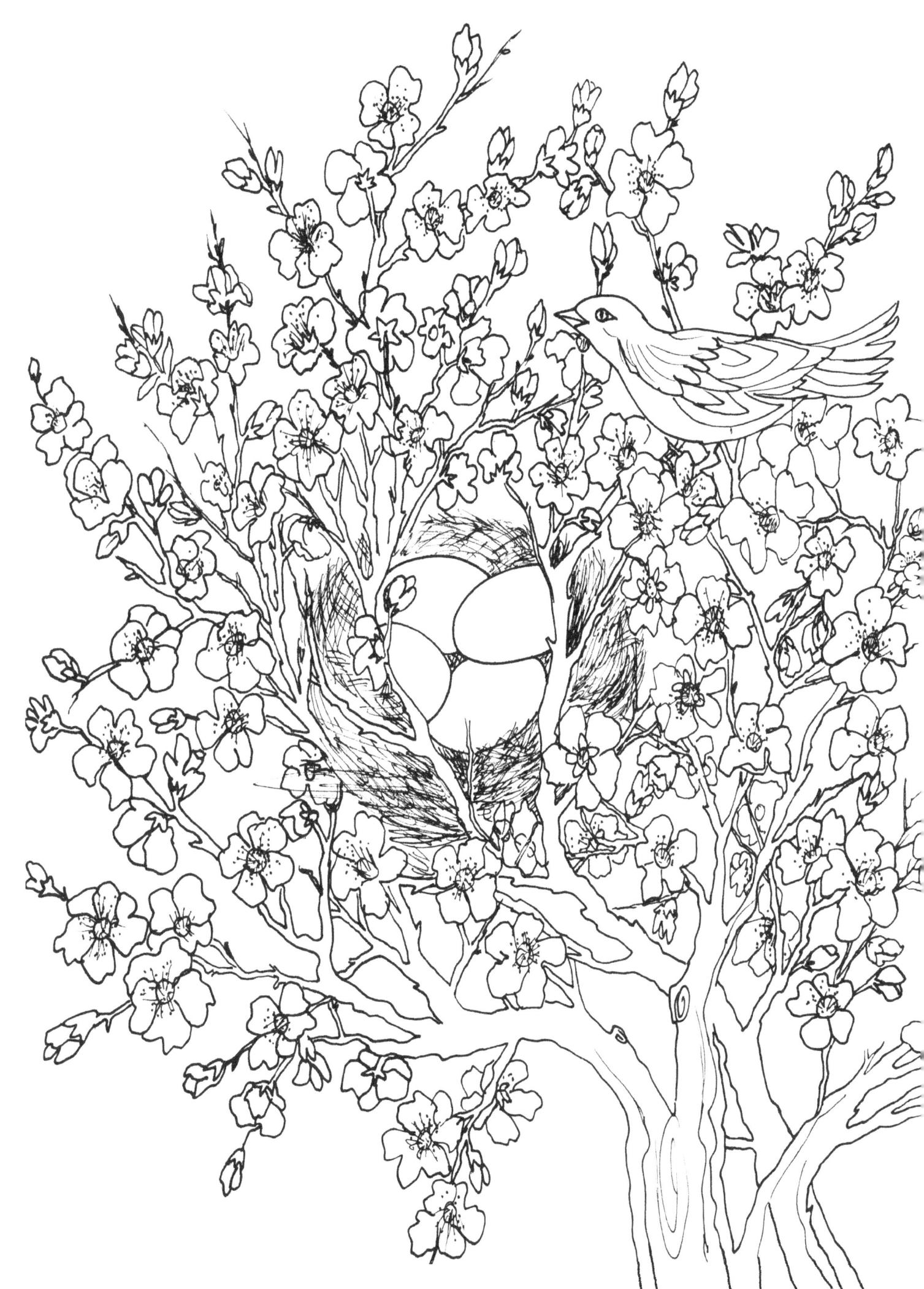

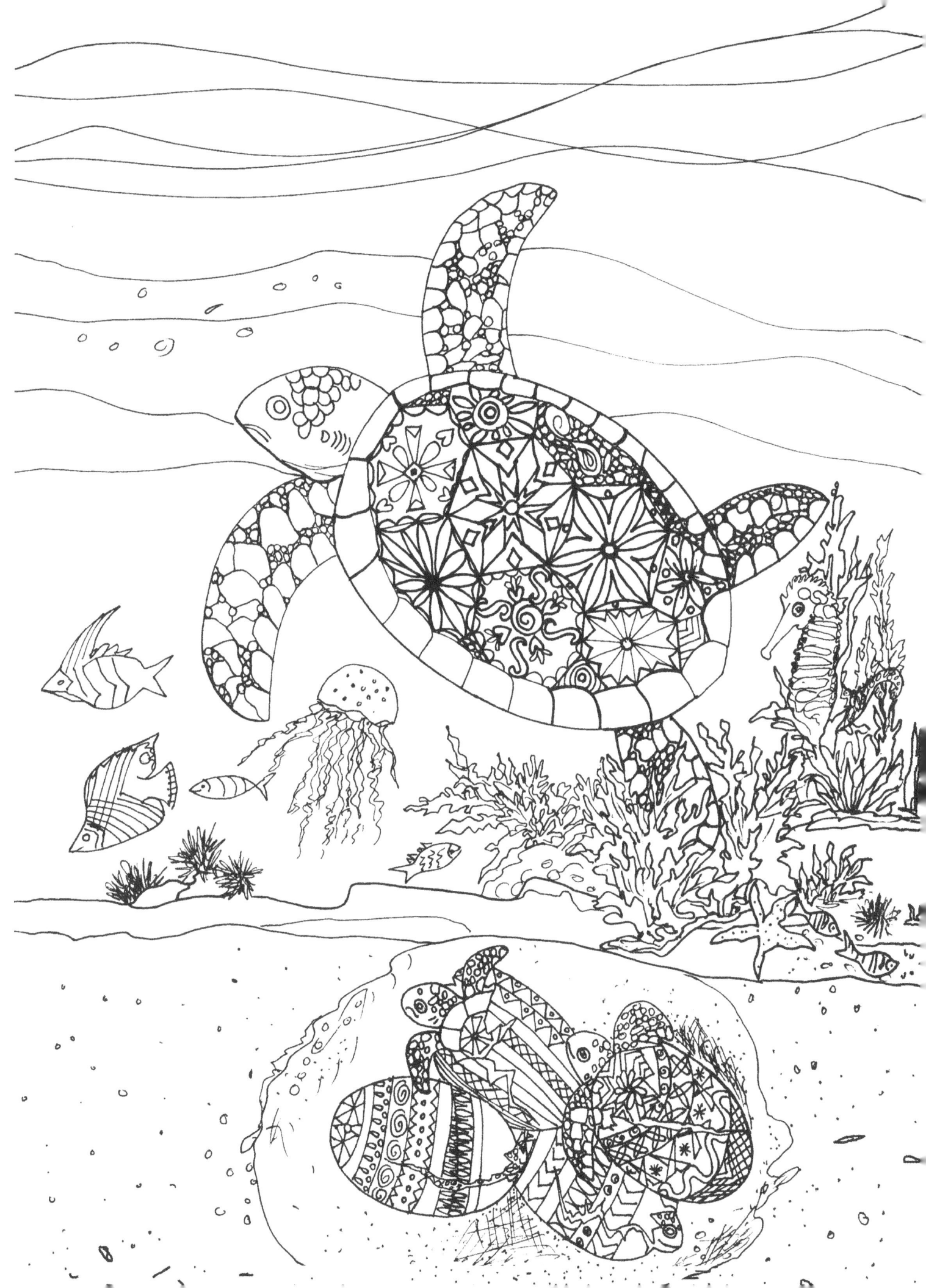

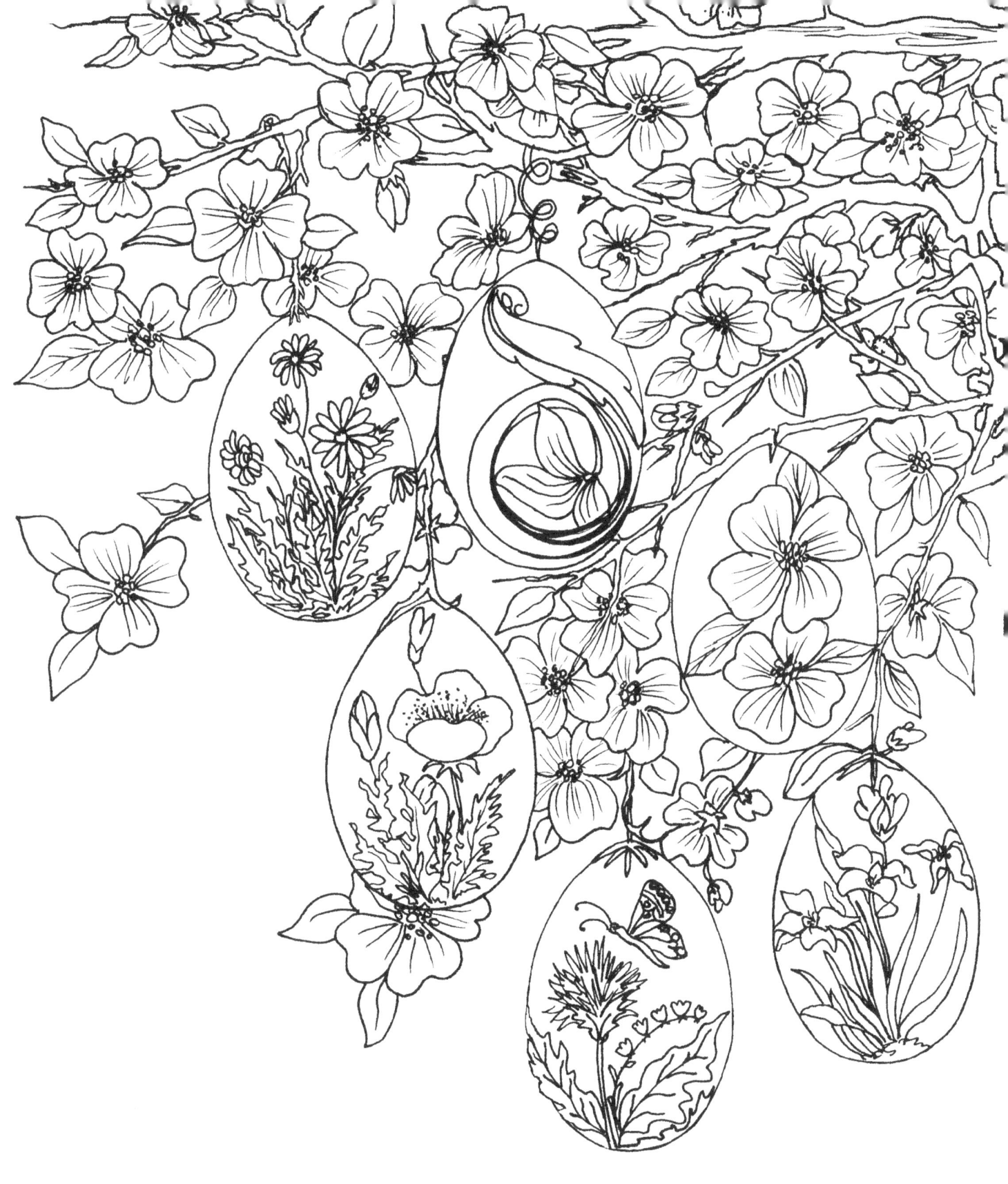

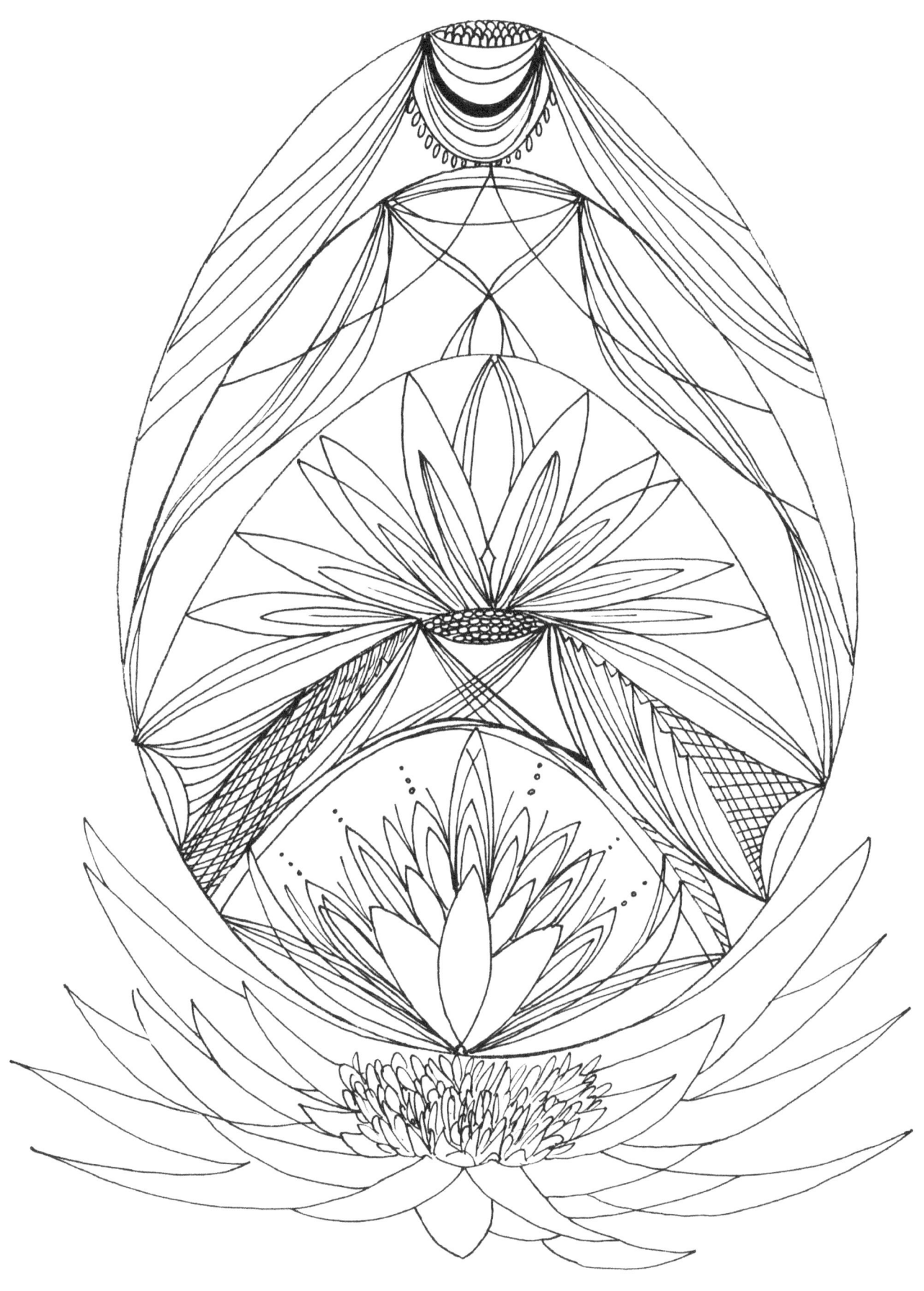

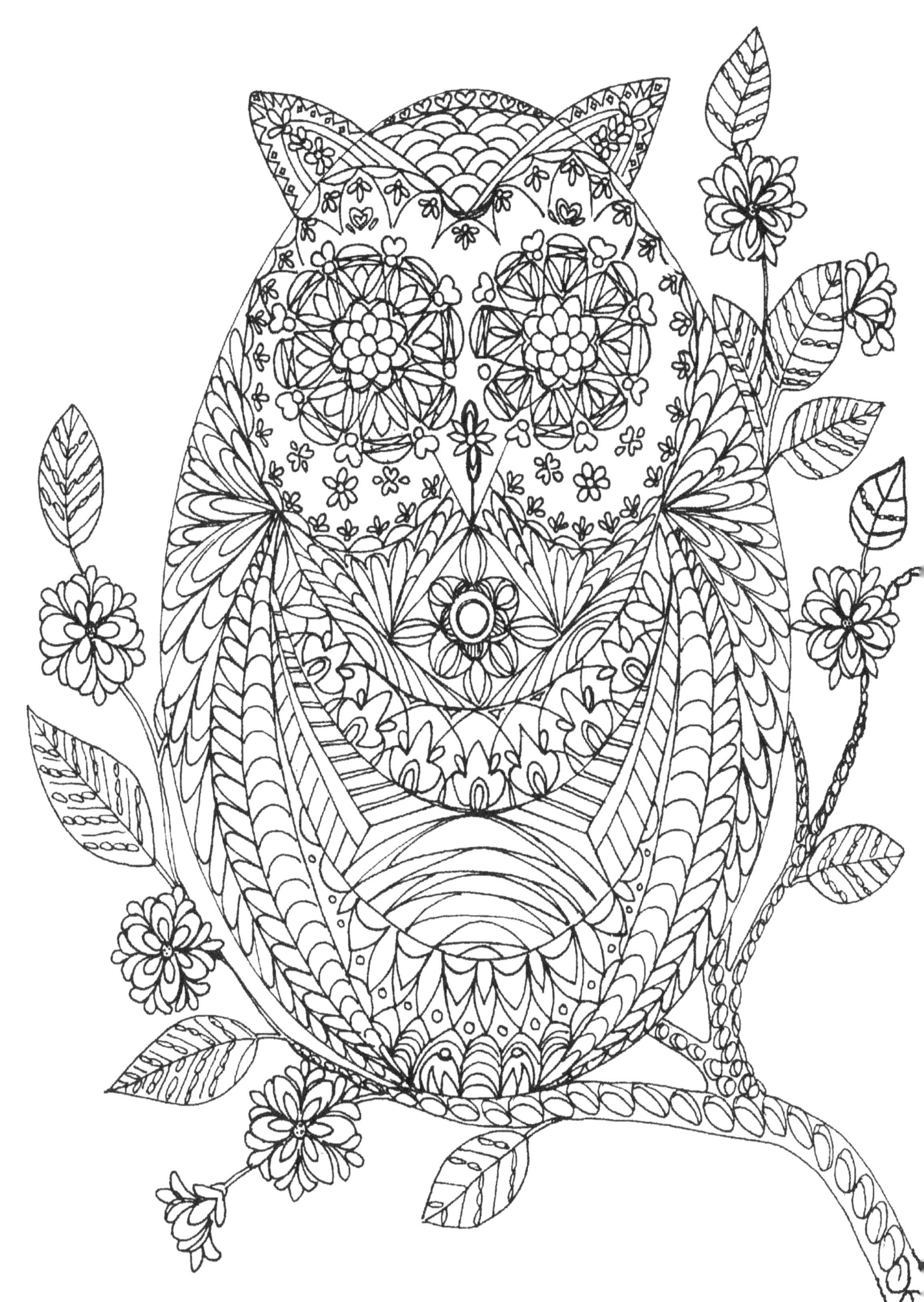

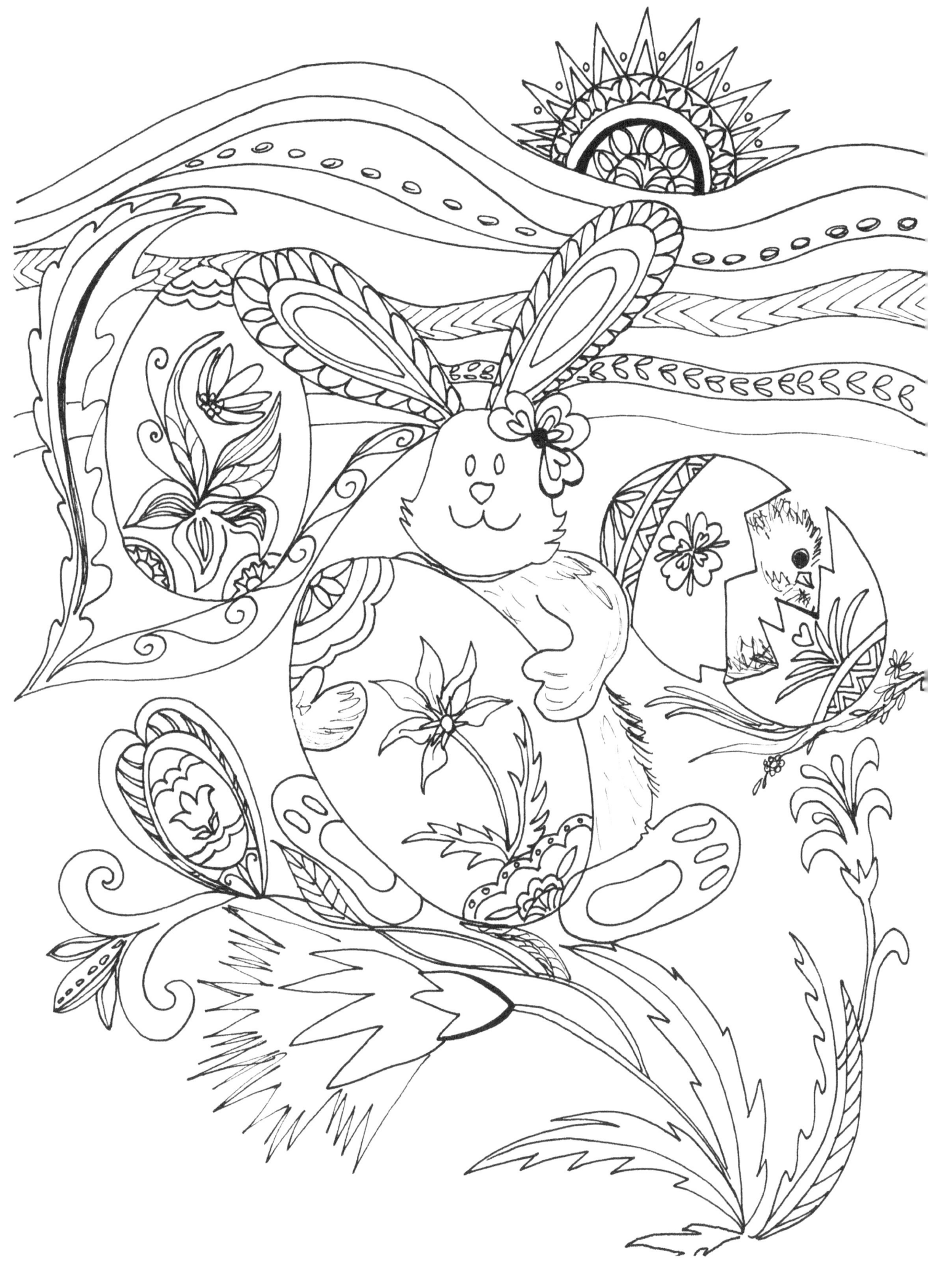

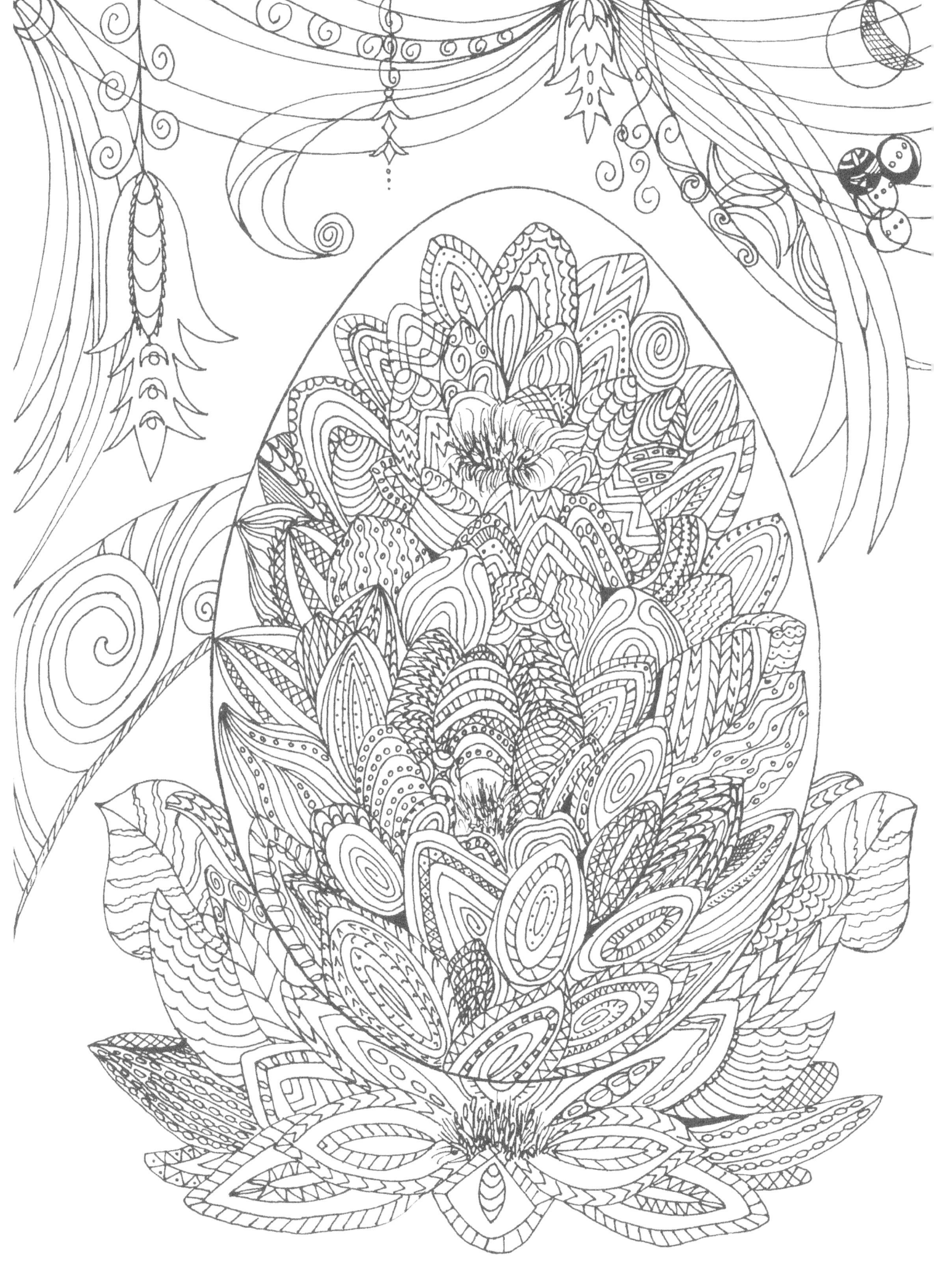

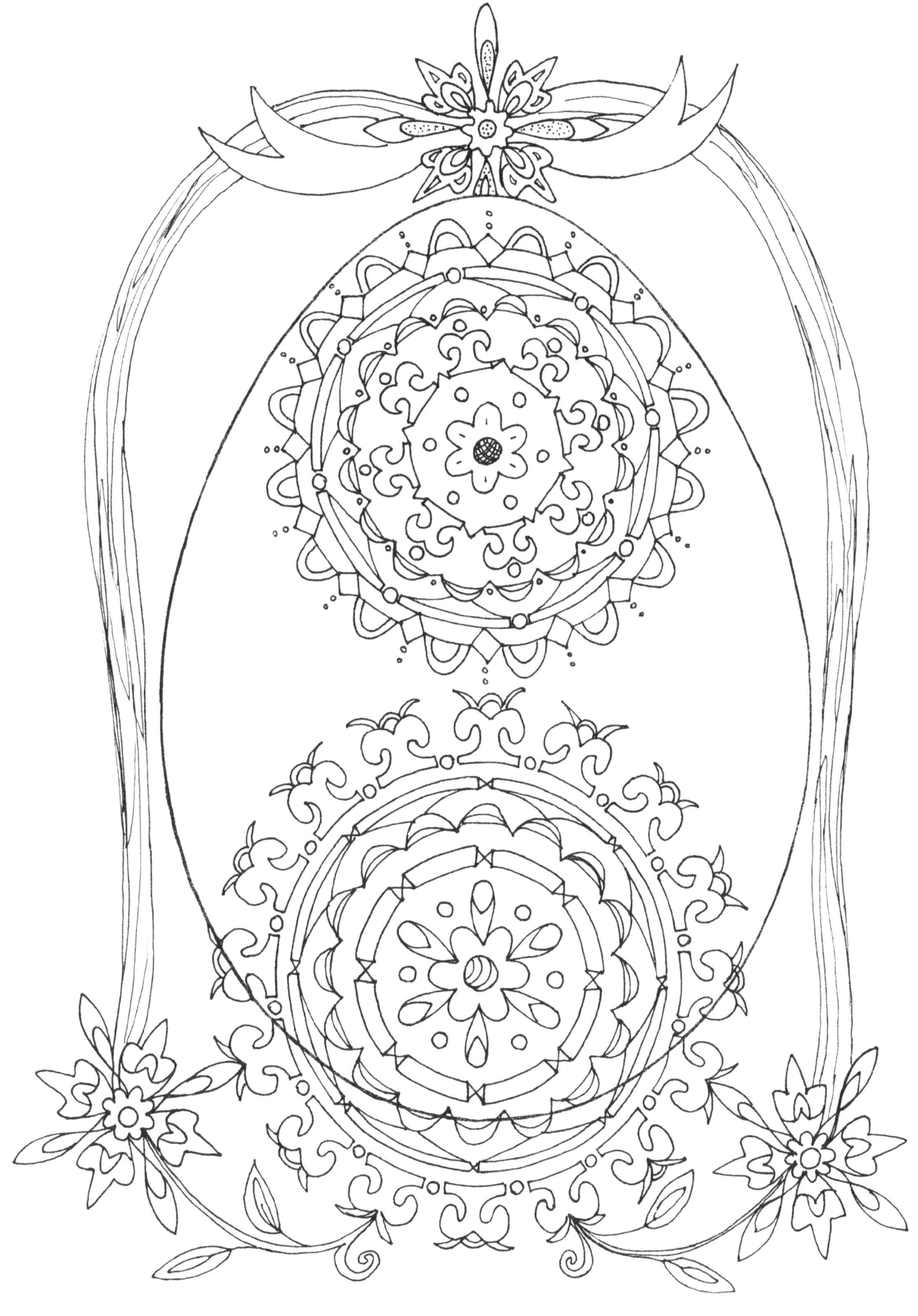

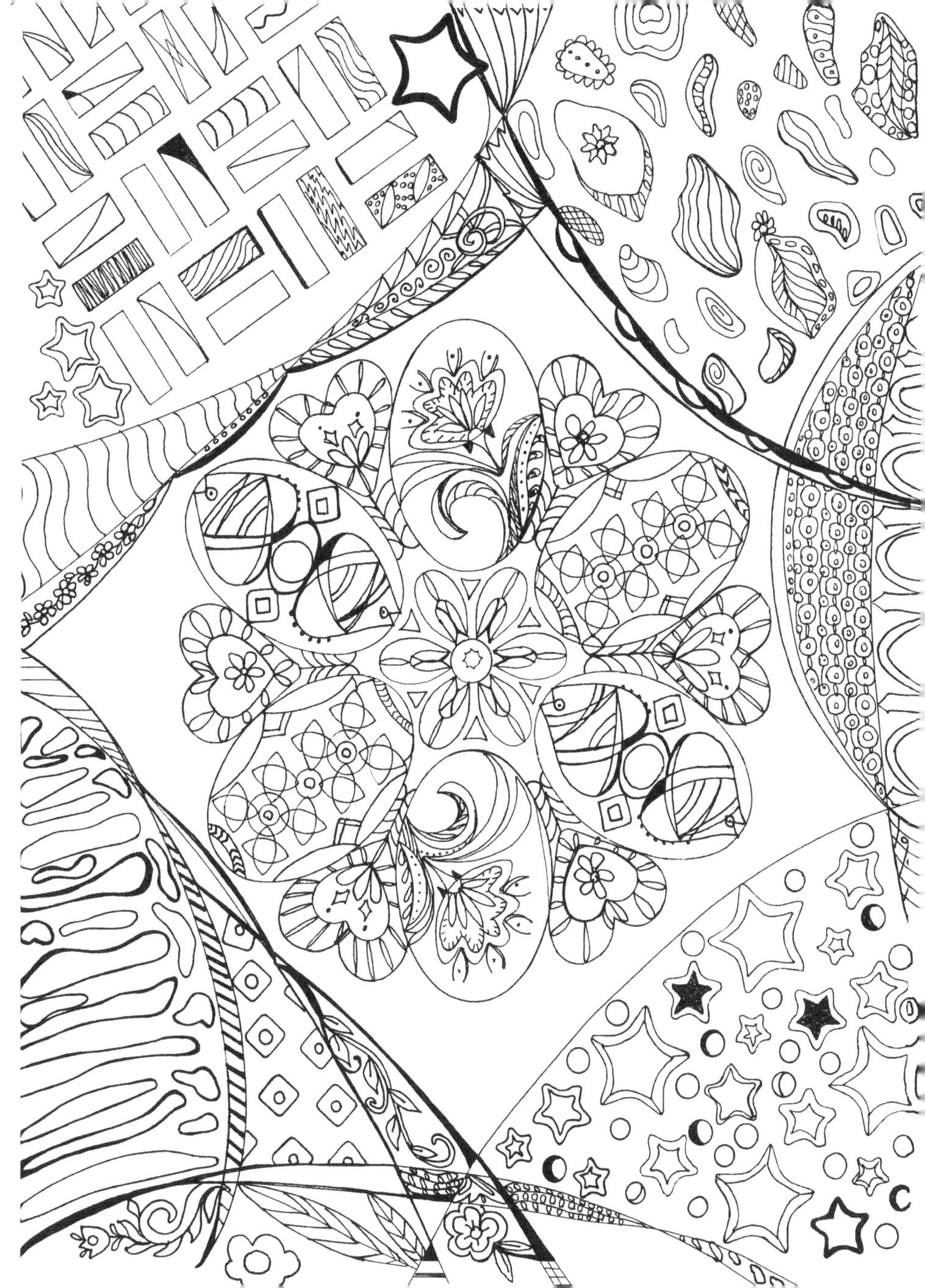

www.ingramcontent.com/pod-product-compliance
Lightning Source LLC
Chambersburg PA
CBHW080557190526
45169CB00007B/2804